# Faith Ringgold

Robyn Montana Turner

Little, Brown and Company

Boston Toronto London

To my friend and colleague Dr. Sandra M. Epps,
who introduced me to Faith Ringgold at the Studio
Museum in Harlem

ACKNOWLEDGMENTS
I'd like to extend my grateful appreciation to the many individuals who influenced the development of this series and this book, including my editors, Maria Modugno and Hilary M. Breed, for tenaciously seeing this book through to completion; Virginia A. Creeden for gathering permissions for the images from around the world; Dr. Vesta Daniel and Aaronetta Pierce for their continuing research about African-American artists; and Dr. Bernice Steinbaum, Faith Ringgold's former art dealer, for sharing her expertise and resources about Ringgold. Finally, a special note of thanks to Faith Ringgold for the hours of time and energy she graciously gave to interviews and reading of manuscript for this project, as well as to her assistant, Vanessa P. Williams, for researching family photographs.

First Edition

Unless otherwise indicated, all artwork reproduced in this book is from the collection of Faith Ringgold. All works by her appear with her permission.

Library of Congress Cataloging-in-Publication Data

Turner, Robyn.
    Faith Ringgold / Robyn Montana Turner.
      p.   cm. — (Portraits of women artists for children)
    Summary: Examines the life and work of the artist whose determination to be true to her African-American heritage brought about an influential new art form.
    ISBN 0-316-85652-5
    1. Ringgold, Faith — Juvenile literature. 2. Afro-American artists — Biography — Juvenile literature. [1. Ringgold, Faith. 2. Artists. 3. Afro-Americans — Biography. 4. Art appreciation.]
I. Title. II. Series: Portraits of women artists for children.
N6537.R55T87   1993
709'.2 — dc20
[B]                                   92-42652

10 9 8 7 6 5 4 3 2 1

SC

Published simultaneously in Canada
by Little, Brown & Company (Canada) Limited

Printed in Hong Kong

After I decided to be an artist, the first
thing that I had to believe was that I,
a black woman, could be on the art scene
without sacrificing one iota of my black-
ness, or my femaleness, or my humanity.
— Faith Ringgold

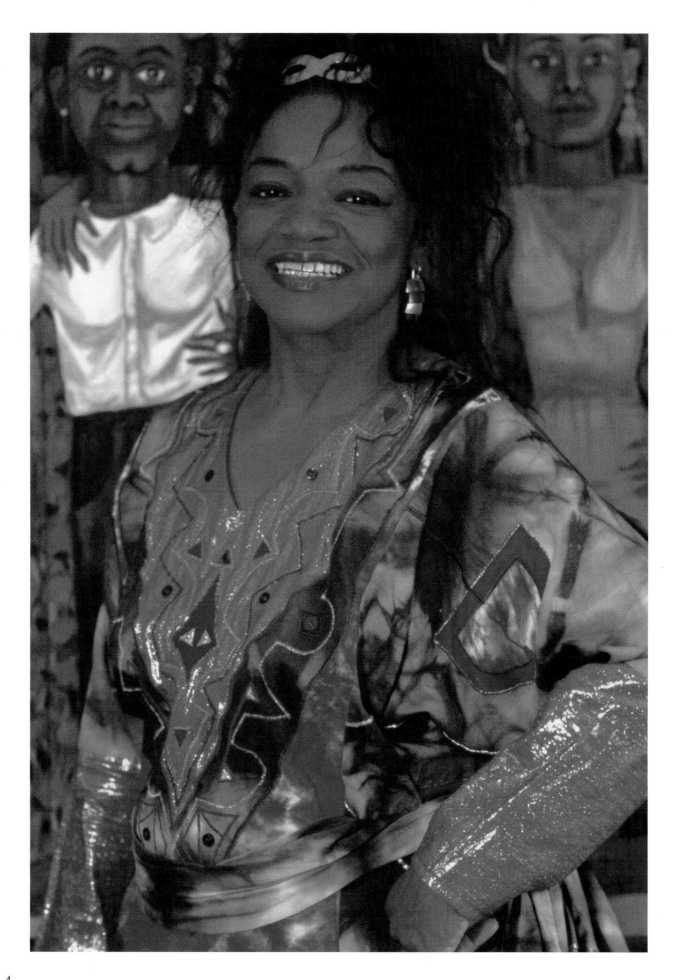

# Faith Ringgold

## (RING-gold)
## (1930 – )

Just 150 years ago, only a few women in the world had become well known as artists. Since then many women have been recognized for their artwork. Today some very famous artists are women. Nowadays both boys and girls are encouraged to become great artists.

But let's imagine that you could go back in time to the turn of the twentieth century — about a hundred years ago. As a young person growing up in America at that time, you might wonder why women artists in your country have only just recently been allowed to attend the best schools of art. You might question why women artists are not welcome at social gatherings where male artists learn from each other by discussing new ideas about art. You might be surprised to discover that women have just recently been permitted to look at nude models to help them learn how to portray the human figure. And you might be disappointed to learn that most young girls are not encouraged to become great artists.

In 1900, African-American women interested in becoming artists faced even greater obstacles. Unfair rules and biased attitudes within many American institutions stood in their way. By 1930, the situation had not improved a lot. At that time in Harlem, a baby girl was born who would become well known as an artist. Her name was Faith Willi Jones. We would come to know her by her married name, Faith Ringgold. Today her works of art hang in museums throughout the world.

**Faith Ringgold with Detail of The Purple Quilt.**
*Photograph by C. Love, 1986.*

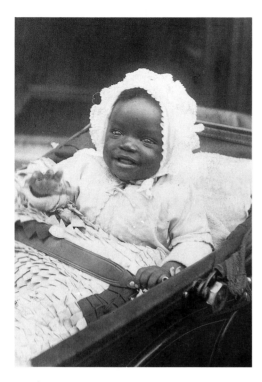

**Faith in Her Pram.** *c. 1931.*
The colorful patterns of Faith's pram quilt, made by her mother, would influence her later artwork.

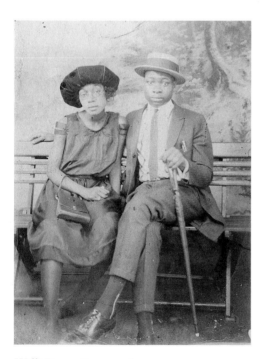

**Willi Posey Jones and Andrew Louis Jones.** *c. 1920.*
Faith's parents pose for a picture ten years before she was born.

On October 8, 1930, while the United States struggled through the Great Depression, a baby girl was born in New York City's Harlem Hospital. Willi Posey Jones and Andrew Louis Jones had hoped for a boy, as their eighteen-month-old son had recently died of pneumonia. A nurse sensed Willi's despair and helped them name the baby girl. "Call her Faith," said the nurse. Willi decided to have faith in her baby girl and offered her own name, too. Faith Willi Jones would soon become her parents' pride and joy.

Faith's seven-year-old brother, Andrew, Jr., and four-year-old sister, Barbara, loved to play with the new baby. Each day they strolled along the sidewalks of Harlem as Willi pushed Faith in her large pram, or buggy. Many years later, Faith would recall the triangular shapes of the colorful pram quilt that her mother had made. She would remember being tucked snugly into the pram and looking up at friendly faces peering down to say, "Hello, Faith."

When Faith was about two, she got asthma, which made it hard for her to breathe at times. Her mother took special care of her. Each morning Willi awoke before anyone else and boiled water so the air would be humid. Before breakfast began, she gave Faith a warm bath. She quickly dressed her in her "snuggies" (thermal underwear) and other clothing that had been heated on the radiator. Then, just for fun, she fixed Faith's hair into special braids or sometimes curls, almost always adding a big bow.

The first breakfast of the day Faith shared with her father. Andrew had a good job driving a truck for the New York City Sanitation Department. He earned thirty-four dollars per week — a generous wage during the days when the average weekly salary was only ten or fifteen dollars. Andrew was a big man with a gentle heart. When he had to reprimand the

children for doing something wrong, his eyes often filled with tears of sorrow.

During the second round of breakfast, Faith ate again with her sister and brother. Then Willi and Faith walked Barbara and Andrew up Sugar Hill to school.

Back at home, Faith played alone. She colored, and she copied etchings onto blank paper. Willi showed Faith how to sew. Soon Faith began to stitch pieces of fabric with a needle and thread to make her own designs. During the next several years, she tried to make shoes, little hats, and pocketbooks — even underwear. She wanted to create her own version of familiar objects usually found in stores. Although Faith enjoyed the challenge, she became frustrated with the incomplete and strange-looking results.

Each Sunday, the mayor of New York City, Fiorello La Guardia, read the comics aloud on the radio. At age four, Faith thought that real people lived inside the radio and talked through the speaker. And she insisted that she be able to read along with the mayor. So Barbara, Andrew, and Willi taught her to read.

When it was time for Faith to enter first grade, she was still bothered by asthma. To help build Faith's strength, Willi prepared health food for her — steamed vegetables, fresh fruit, lamb, chicken, veal, cornmeal gruel, and homemade lemon ice cream made with skimmed milk, which Faith thought tasted horrible. But she ate the food anyhow to stave off bronchial infections that sometimes go with asthma. If Faith felt well enough, she went to school. Willi packed her lunch box with nutritious cookies. She even sewed Faith some special clothes for school.

When Faith's asthma was at its worst, Willi often taught her daughter at home. She purchased the first-grade schoolbooks at a bookstore. Faith learned her

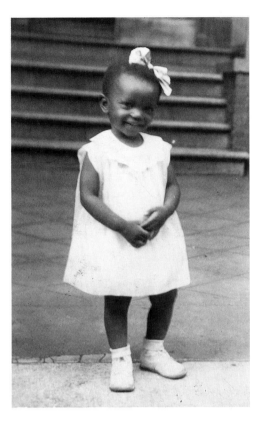

**Faith.** *c. 1932.*
On warm afternoons, two-year-old Faith enjoyed the Harlem sunshine.

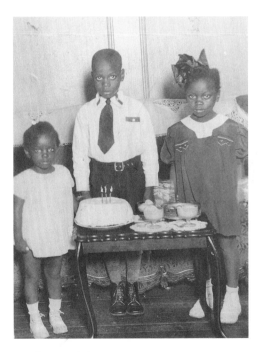

**Faith's Birthday Party.** *1933.*
Faith, Andrew, and Barbara celebrate Faith's third birthday.

lessons so well that when she periodically went back to school, she was ahead of her classmates. And she had become the best artist in the class.

During her days away from school, Faith learned both from her textbooks and her surroundings. After she and her mother had walked Andrew and Barbara to school, they usually went to museums or to the theater. Faith saw major actors and musicians perform at the Apollo Theater in Harlem and downtown at the Paramount Theater, the Roxy Theater, and Radio City Music Hall. In these places, Faith saw her first stars: Ella Fitzgerald, Duke Ellington, Judy Garland, Count Basie, Benny Goodman, Billie Holiday, Cab Calloway, Lena Horne. She noticed that these performers created their art for an audience who appreciated them. The young girl began to dream of the time when someday she, too, would be a star.

On the way back to school to pick up Barbara and Andrew, Faith would persuade Willi to stop into the five-and-ten-cent store for candy. Even though Faith could not eat the candy because of her health-food diet, she wanted to have something special for her sister and brother.

Each evening the three children ate together and then went to their rooms to study. Later, when their father came home from his sanitation job, Willi prepared a bath and dinner for him. Polio and tuberculosis were common in those days, so Faith's parents were careful to keep germs away from their children. Many people changed from their uniforms into clean clothes before they went home to their families. And many parents didn't even allow people from outside the family to greet their children with a kiss.

On hot summer nights, Faith's family sometimes cooled off with the neighbors on the tar-paper roof of their tenement building. The adults laughed, told

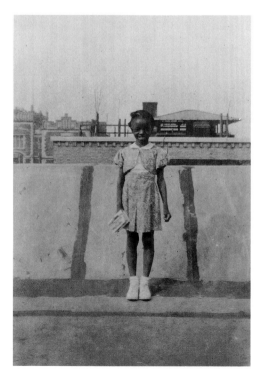

**Faith on Tar Beach.** *c. 1935.* As a five-year-old playing on the tar-paper-covered roof of her apartment building, Faith did not know that she would become an artist whose works would reflect special memories of her childhood.

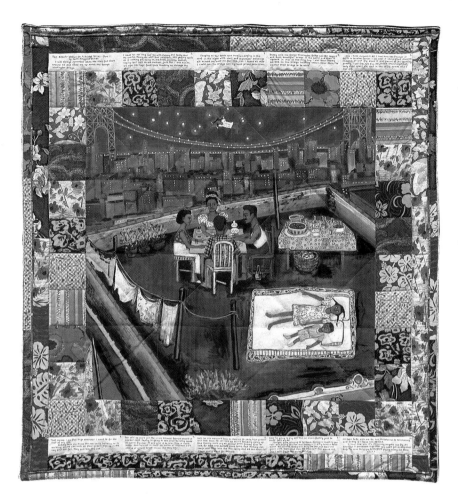

Faith Ringgold. **Tar Beach.**
*Woman on a Bridge Series. 1988.*
*Acrylic on canvas; tie-dyed and*
*pieced fabric. 74 x 69 inches.*
*Collection of The Solomon R.*
*Guggenheim Museum.*
Faith's friends and family
often relaxed together on the
roof of their apartment build-
ing. They enjoyed playing on
this "tar beach" and on the
real beach in nearby New
Jersey.

stories, and played cards around an old green card
table. Children got to stay up late if they promised to
lie quietly on a mattress. All evening long, the
children ate and entertained themselves by creating
imaginary stories about the stars and the sparkling
lights of the New York skyline.

The lights of the George Washington Bridge
especially dazzled Faith. She always felt that the
arched pathway across the heavens was hers. She
wore it in her dreams as a giant diamond necklace
and flew above it in her imagination. Later, as an
adult, she would sew a story quilt and write a
children's book about her memories of the bridge and
of the roof she called Tar Beach. Through her art,
Faith would send a message that people are free to go
wherever they wish.

By the time Faith reached second grade, she was
attending school on a regular basis. Her classmates

**The George Washington
Bridge.** *Copyright © 1989 by
Bill Hickey. The Image Bank.*

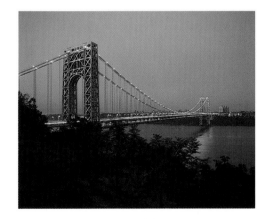

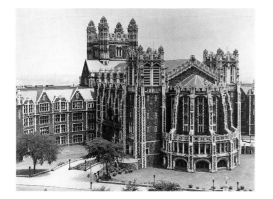

**Shepard Hall, The City College of the City University of New York.** *Reprinted by permission of City College Archives.*
Even as a young child, Faith was fascinated with the Gothic architecture of City College.

admired her artwork and chose her to paint the image of Santa Claus on the Christmas mural. This made Faith feel good about her artistic abilities.

When Faith was twelve years old, her parents got a divorce. By now, the United States had entered World War II. With most of the men away at war, jobs became available to women. Willi was glad to find work doing something she enjoyed — sewing jackets in the garment district of New York City. As a fashion designer and garment maker, she learned to operate powerful sewing machines. Faith lived with her mother, sister, and brother and continued to spend time with her father when he was not working. He helped her practice reading. And he encouraged her to do art by giving her an easel and a drawing board.

Faith took art classes at school until she got to high school, where she was encouraged to take only academic classes such as English, math, and history. But that did not stop Faith. At age sixteen, she began drawing portraits of family members and friends who came to visit at home. Sometimes they grew weary of sitting still and did not like the way the portraits looked. But Faith kept practicing, even if it meant creating pictures of people that displeased them.

In 1948, after high school graduation, Faith wanted to enroll in college. Even as a small child walking up the hill to elementary school, she had planned to attend the City College of New York. Faith recalled seeing hordes of boys pouring out of the subway, heading up that hill. When Willi had explained they were going to college, Faith had known that she, too, would go there.

At the time when Faith applied to City College, women were not allowed to attend the school of liberal arts. Faith was terribly disappointed. She discovered, though, that she could seek art training

in the school of education, which had always accepted women. This plan pleased Willi, since Faith's grandparents and cousins had been teachers. Now Faith could plan to teach art for a living and create her own art when she could find the time.

The art classroom at City College was on the top floor of an old Gothic building. Through the skylights in the high ceilings, the sun shone onto plaster casts of Greek busts. Faith's drawing and painting teachers had their students copy the lines and forms of those sculptures.

But soon Faith felt a need to apply what she was learning to her own experiences. Throughout her life, all of Faith's teachers had been white. Even now she was learning about art by copying Greek sculpture. Who would help her learn to express her African-American heritage?

Once again, Faith set about on her own to overcome an obstacle. She began by mixing colors of paints to achieve dark skin tones. Instead of dark brown tones, however, her first results were orange and green. No one knew how to show her what to do. In fact, the art teachers became annoyed with her efforts. She continued on her own to practice mixing paints. She also experimented with African-American themes as subjects for her art.

Before she graduated from City College, Faith fell in love with and married Robert Earl Wallace, a classical and jazz pianist. By the time she was twenty-two, she had two children, Michele Faith Wallace and Barbara Faith Wallace. The marriage would not work out, however, and six years later, she would be divorced. In 1955, the young mother graduated from City College with a degree in fine arts and a teaching license. She was ready to teach art in the New York City public schools.

During her eighteen-year teaching career, Faith

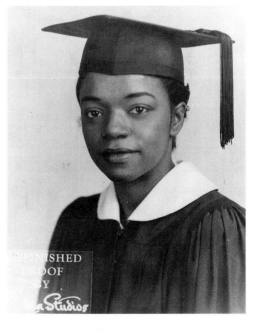

**Faith at Her College Graduation.** *1955.*
Upon her graduation from City College, Faith was prepared to launch a long and exciting career in teaching and the arts.

Faith, Willi, Barbara, and Michele on Board the S.S. *Liberté* Bound for Paris. *1961.*

Faith and Burdette ("Birdie") Ringgold. *1960.* This picture of Faith and Birdie was taken two years before they married.

learned as much from her students as they did from her. One day in 1955, a student told Faith about her brother, James Baldwin, a highly respected African-American writer. When Faith read his works, her mind came alive with images of her culture.

Soon Faith realized that she must follow her dream of becoming a professional artist so that she could express her thoughts and feelings. She started by earning a masters of arts degree from City College. Then, in 1961, she traveled to Europe with Willi, Barbara, and Michele to study paintings and drawings in the museums of France and Italy. Faith was astonished to see the bold colors of the paintings that had been mere pictures in her textbooks. She could hardly wait to get home to set up a studio of her own in her dining room.

Now Faith was becoming a serious artist and could think of little else. The next year, however, her attention shifted once again to marriage. Her name now changed to Faith Ringgold. Soon, both she and her second husband, Burdette ("Birdie") Ringgold, focused on her career by showing her paintings — mostly landscapes and still lifes of fruits — to several New York art dealers. But gallery owners discouraged Faith because she was African-American. They acted as though she had no right to paint with the colors and techniques that she had learned about in college and in Europe. So Birdie encouraged Faith to search further for her own special style. She began to think about experiences that were close to her — to get in touch with who *she* was. She put away her oil paintings of houses, landscapes, boats, and oceans.

In 1965, Ringgold met a powerful African-American poet and playwright, Amiri Baraka, then known as Leroi Jones. His works, along with those of James Baldwin, inspired her to explore her heritage. The next year she met several African-American

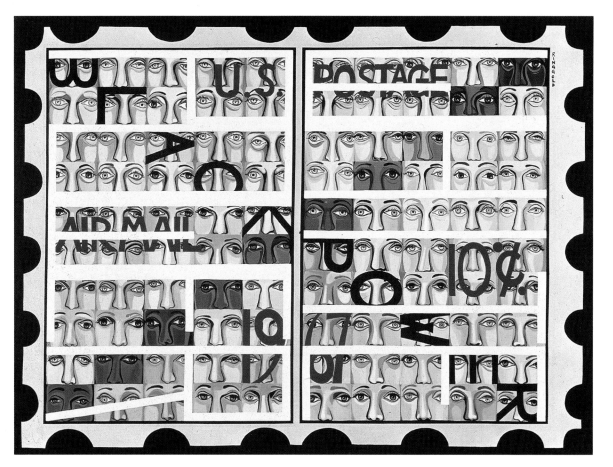

visual artists — including Romare Bearden, Jacob Lawrence, Louis Mailou Jones, Norman Lewis, and Hale Woodruff — whose paintings had become well known. Their art continued to inspire Ringgold. In 1966, she participated in the first African-American exhibition in Harlem since the 1930s.

As the 1960s progressed, Ringgold expressed her political beliefs through several series of paintings. *U.S. Postage Stamp Commemorating the Advent of Black Power* looks like a huge postage stamp. Ninety light faces and ten dark faces represent the percentages of whites and African-Americans in the United States. The dark faces and the words *BLACK POWER* cross to form an X. This image points out Faith's frustration with racial inequality. Finally she was painting about something close to her. She was developing a mature style of her own.

As Ringgold interacted with a wider circle of artists, she took part in demonstrations in front of art

Faith Ringgold. **U.S. Postage Stamp Commemorating the Advent of Black Power.** *The American People Series. 1967. Oil on canvas. 72 x 96 inches.* This painting in the American People series represents Ringgold's feelings concerning the disadvantages of being African-American in the United States. Like many artists at that time, she used the American flag, posters, maps, and postage stamps as subjects for her paintings.

13

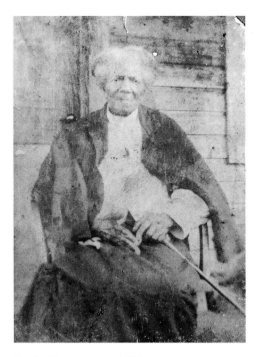

**Susie Shannon.** *c. 1900.*
Susie Shannon, Ringgold's
great-great-grandmother,
who was part Cherokee and
a former slave, lived to be
110 years old.

museums and galleries to demand that they include the artwork of women and African-Americans in their collections. She became an activist for civil rights.

In 1972, something happened to take Ringgold a step further toward expressing her true heritage. Teaching at Bank Street College in New York City, she was challenged by one of her students. Why did Ringgold encourage her students to create with fabric and beads — the media of African women — the student questioned, when her own artwork was made of paint on canvas?

At first Ringgold rejected the question even though she had sensed something distant and cold about the process she was using to paint. Soon she realized the worth of her student's words. Why *not* work with fabric and beads? After all, the women in her family had worked with these media for generations.

Suddenly Ringgold felt a link with her great-great-grandmother, Susie Shannon, a "house girl" who had been a slave on a plantation. Susie had taught Faith's great-grandmother, Betsy Bingham, to sew quilts. Betsy's granddaughter, Willi, had told Faith stories about watching Betsy boil and bleach flour sacks until they were as white as snow to line the quilts she made. Ringgold recalled the days when Willi, who operated powerful sewing machines in the garment district, had taught her to use the smaller sewing machines at home. Willi had taught her daughter everything about sewing. Now Ringgold knew she wanted to carry on the tradition of working with fabric and beads.

That summer, on another trip to Europe, Ringgold discovered *tankas*, cloth frames for sacred paintings from Tibet. When she returned home, she made some *tankas* for her paintings. The cloth border enhanced the images, and they could be easily rolled

up and carried around. Ringgold knew she was onto something wonderful. Soon she asked Willi to make *tanka*s as frames for her other paintings.

As much as she liked the flat *tanka*s, Ringgold wanted her art to have a more human dimension. So she reflected upon her childhood in Harlem, where people had been close to each other in a friendly and beautiful place. She remembered the faces and the souls of the people — everything about them. She began to form soft sculptures in the style of African masks. These pieces featured women who had been role models to her. All of those women had a sense of themselves. They were bold, not shy. They did not hold back. They did the best they could with what they had. The subjects of her soft sculptures, such as *Mrs. Jones and Family*, also came to include children, the elderly, and heroes such as Dr. Martin Luther King, Jr.

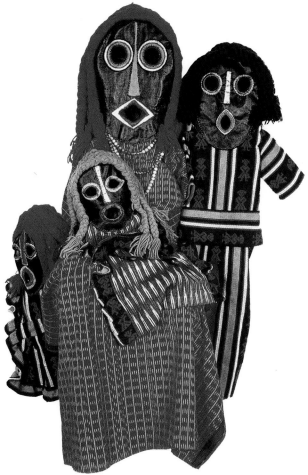

Faith Ringgold. **Mrs. Jones and Family.** *The Family of Woman Mask Series. 1973. Sewn fabric and embroidery. 60 x 12 x 16 inches. Mrs. Jones and Family* is a soft sculpture of Ringgold's family — Willi, Andrew, Barbara, and Faith. The mouths of the life-size mask figures are open to symbolize the rich story-telling tradition of Ringgold's culture.

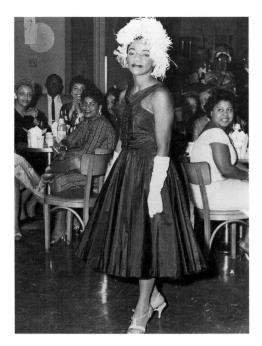

**Faith Ringgold Modeling in One of Her Mother's Fashion Shows.** *1950.* As a young woman, Ringgold sometimes modeled dresses that her mother had designed and sewn.

In the same year that she sculpted *Mrs. Jones and Family*, Ringgold gave up teaching to be a full-time artist. Willi, who had developed a busy career as a fashion designer, continued to help her daughter by sewing *tanka*s and costumes for her soft sculptures. Ringgold was so resourceful that she packed her sculptures into trunks and sent them around to college campuses to be displayed. She also traveled to give art lectures and workshops. Without the help of gallery owners or dealers, Ringgold was getting her art before the eyes of the public.

During the next few years, Ringgold's art career thrived. She began doing theatrical performances to go with her art exhibits. In 1976, on her first trip to Africa, Ringgold observed the art and the people of Ghana and Nigeria, which gave her new ideas to weave into her own style.

Ringgold's daughters, Michele and Barbara, became women during the seventies. They both graduated from college. Barbara married. Michele published a book. Life for the Ringgold family could not have been better. In 1981, however, Ringgold was suddenly faced with the saddest event of her life — the death of her mother, who was seventy-nine years old. To express her grief, Ringgold turned to a friend and companion — her art.

Perhaps because she missed working with Willi, Ringgold changed her medium and style. She painted abstract images on canvas. No longer did her subjects look familiar. Instead, she painted irregular shapes moving about in bright colors. Each shape may have been taken from an idea or a memory.

Birdie, Barbara, and Michele were surprised to see this new means of expression. They could almost feel and listen to the shapes. Ringgold explained that the images came from deep within her soul. The mysterious nature of the paintings left them nameless

until Birdie suggested calling them the Emanon series, which spells *no name* backwards, a substitute for *Untitled* in jazz circles.

The next year brought both tears and joy. The family experienced more sorrow upon the death of Faith's sister, Barbara. But their spirits were renewed with the birth of Faith's first grandchild — Baby Faith — young Barbara's daughter.

Even before Baby Faith was born, Barbara and Michele talked to her through the walls of Barbara's womb. They wanted to instill the family's rich history of language early on. So it came as no surprise that, at six months, Baby Faith pointed toward one of her grandmother's brand-new abstract paintings and said her first word: "Dah!" From that utterance came the title of a series of six abstract paintings. The Dah series expresses Faith's sorrow in losing her mother and her sister, as well as her joy in gaining a grandchild.

Faith Ringgold. **Dah #3.** *1983. Acrylic on canvas. 72 x 54 inches.*

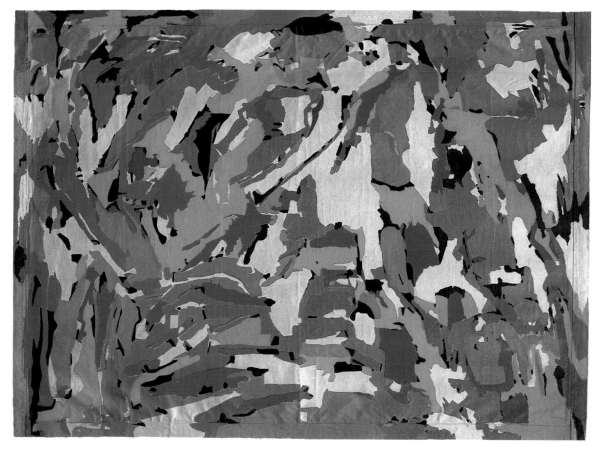

More than twenty years had passed since Ringgold had set out to become a professional artist. On her own and with Birdie, she had developed an audience for her art across the country. Finally, in 1986, she began working with a New York art dealer who showcases the works of women and ethnic minority artists. At last she had a market for selling her art. Now Ringgold could focus strictly on *doing* art.

Just as Ringgold was experiencing newly found freedom in her career, *Groovin' High* shows jubilant movement. Dancers shift in polyrhythms, an African way of having a variety of rhythms around you at the same time. Even the figures are different sizes, moving in different directions and in different spaces. In the African tradition of the Kuba people of Zaire, Ringgold sewed her favorite motif — four triangles in a square — and quilted them together to form the border. If you look closely, you can see that she also strengthened the painted canvas by stitching

Faith Ringgold. **Groovin' High.** *1986. Acrylic on canvas; tie-dyed, printed, and pieced fabric. 56 x 92 inches. Collection of Barbara and Ronald Davis Balser.*

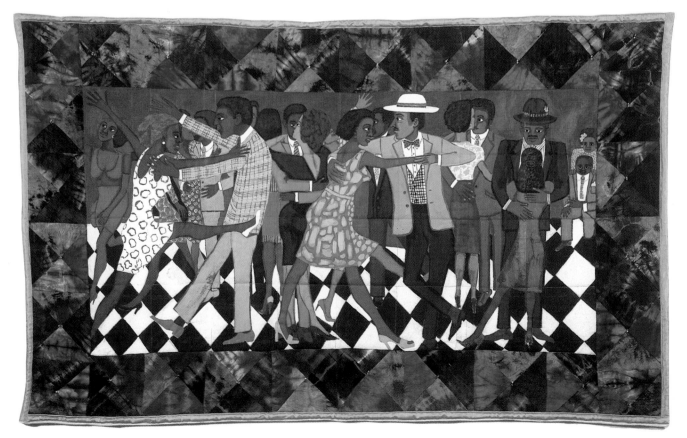

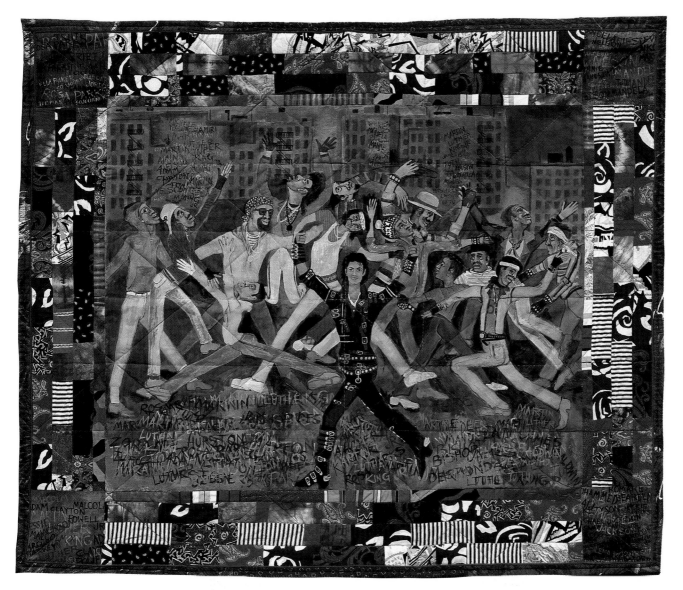

Faith Ringgold. **Who's Bad?**
*1988. Acrylic on canvas;
pieced fabric. 70 x 92½ inches.*
Ringgold created *Who's Bad?*,
a quilt that celebrates Michael
Jackson's socially conscious
artistry.

rows of large squares across it. Now Ringgold would call herself "a painter who works in the quilt medium."

Across the foreground of the quilt *Who's Bad?*, Michael Jackson dances jubilantly — his toes clicking on the graffiti names of African-American heroes. In the middle ground of the canvas, polyrhythmic figures bend, twist, reach, leap, jump, and dance to music the viewer can almost hear. More names rise above them as graffiti on the skyscrapers that fill the background. Even the corners of the colorful quilt remind us of heroic African-Americans who are so good, as Ringgold says, they are "bad."

19

Working on her quilted paintings, Ringgold realized that she had more to say than images alone could convey. She felt a need to write down stories. After all, she had grown up listening to Willi tell family stories in the oral tradition of their heritage.

One day, Ringgold thought of a way to publish her stories through her art. She would write her stories onto her quilts. Then everyone who saw her artwork would also read her "story quilts."

The stories on Ringgold's quilts are dilemma tales. They present problems without solutions. In this way, Ringgold follows an African tradition in which the storyteller does not make judgments. Instead, she leaves the audience with questions that might have many answers.

*Church Picnic* tells and shows the story of an African-American gathering in Atlanta, Georgia, in 1909. The event takes place during the time of Willi's childhood, a time when southern African-Americans were hopeful about the future. The banner on the ground lets us know that this is a church picnic in the urban south. The picnickers sit on patterned blankets and turn their eyes to the focal point of the composition — the minister and a young woman dressed in pink.

The storyteller is the woman seated beside her son, who touches her shoulder, in the upper right of the quilt. Later, at home, the storyteller describes the picnic to her daughter, Aleathia, whom she assumes is in another room.

Ringgold wrote the words exactly as she imagined that they were said — in a southern dialect. For example, the mother says, "The Reverend and Miss Molly was sure 'nuff in love at the picnic. The way he took her in his arms, and she look up at him so tender. They in love chile."

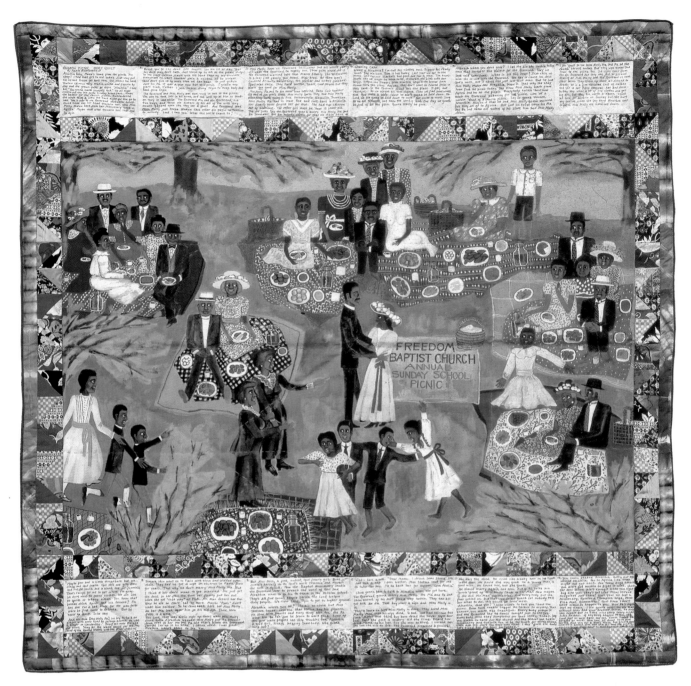

Midway through the story, the mother realizes her daughter is not at home after all, but nevertheless continues to talk to herself. Later, just before Aleathia returns, we learn that she too is in love with the reverend, and that she stayed away from the picnic to avoid the pain of seeing him with Miss Molly. With no solution in mind, the mother consoles herself by saying, "God don't give us no more than we can bear."

Faith Ringgold. **Church Picnic.** *1988. Acrylic on canvas; pieced fabric borders. 74½ x 75½ inches. Collection of The High Museum, Atlanta, Georgia. Gift of Don and Jill Childress through the 20th Century Art Acquisition Fund.* Ringgold wrote the story of the *Church Picnic* story quilt on cotton canvas, which she sewed onto the top and bottom of the quilt. It hangs in the permanent collection of the High Museum, in Atlanta.

To dress the characters in the *Church Picnic* story quilt, Ringgold recalled the clothes people wore to church when she was young — Sunday-best dresses, hair-ribbon bows, white socks, patent-leather shoes, starched shirts, suits, and ties. After church, families had picnics in the parks of Harlem. They brought picnic baskets, linen napkins, fine tablecloths, china plates, glasses, and sterling silverware.

Like *Church Picnic*, several of Ringgold's story quilts celebrate mealtime in the African-American community. To create them, she drew from her imagination, her knowledge of historical events, and memories.

A favorite memory was of Willi's Sunday evening desserts — sweet-potato pie, pound cake, or peach cobbler. Sometimes the family would have company for this special treat. Of course, Willi's table was formally set. On Sunday evening, the children got to listen to the radio.

The elegant table setting and the dressed-up guests of *Harlem Renaissance Party* are reminders of the Sunday evening desserts and Sunday afternoon picnics from Ringgold's childhood. But this story quilt is about a fictional event and character — a deaf woman named Cee Cee Prince, who stands in a colorful African dress that she has quilted.

Even though Cee Cee comes from Ringgold's imagination, she is a lot like Ringgold in real life. They both adore quilting colorful wall hangings, coverlets, and bags. Like Ringgold, Cee Cee likes to dance and perform. Cee Cee is married to a dentist, however, who sits at the head of the table. Their daughter, Celia, seated left of Cee Cee, shrinks from embarrassment because her mother loves to dance to her own music and wear a mask in front of the distinguished dinner guests.

The guests are famous artists from the era of the

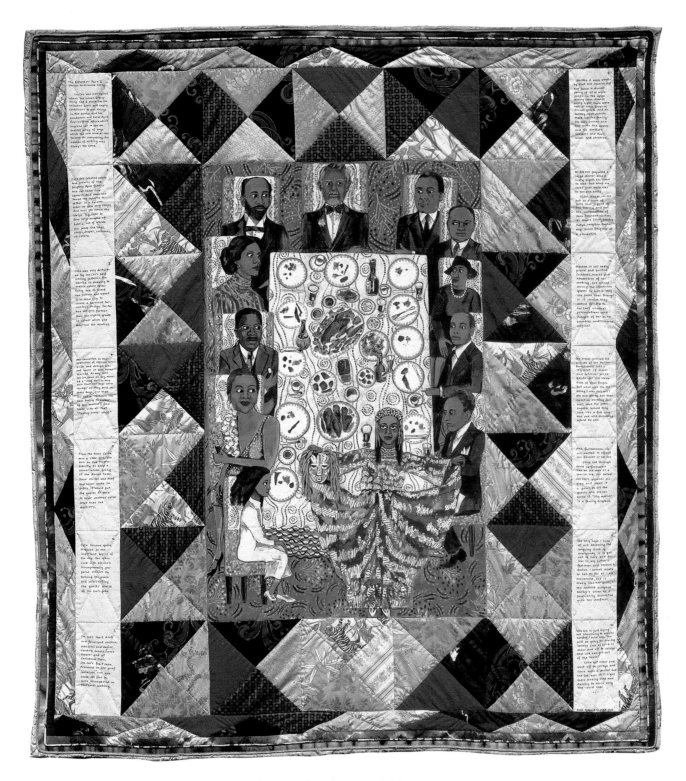

Harlem Renaissance. During this time, from 1919 to 1929, African-American painters, sculptors, musicians, poets, novelists, and dramatists flocked together in Harlem. Their art left a rich cultural legacy. Indeed, Ringgold's invention of the story quilt reflects that same spirit of being creative and true to yourself.

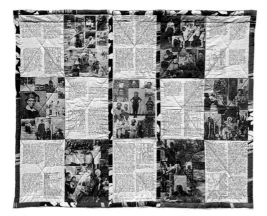

Faith Ringgold. **Change: Faith Ringgold Over 100 Pounds Weight Loss Performance Story Quilt.** *1986. Photo etching on canvas. 57 x 70 inches. Detail below.* Ringgold traveled around the country to perform live dramatizations of the story and images on this quilt.

During the late 1980s, Ringgold performed *Change: Faith Ringgold's Over 100 Pounds Weight Loss Performance Story Quilt* on stages across the United States. Audiences first viewed the quilt, which features photographs of Faith's life with the story that explains how she overcame her weight problem. Then they watched her act out the story on stage.

The performance needed only a few props. As she recited the words of the story quilt, Ringgold dragged around a black plastic bag filled with a hundred pounds of water to show the heavy burden she had been carrying as body weight. "I can CHANGE. I can do it. I can do it. I can CHANGE. I can CHANGE. Now!" she chanted to the beat of African drums. The story quilt and performance remind the audience that with determination people can change their lives.

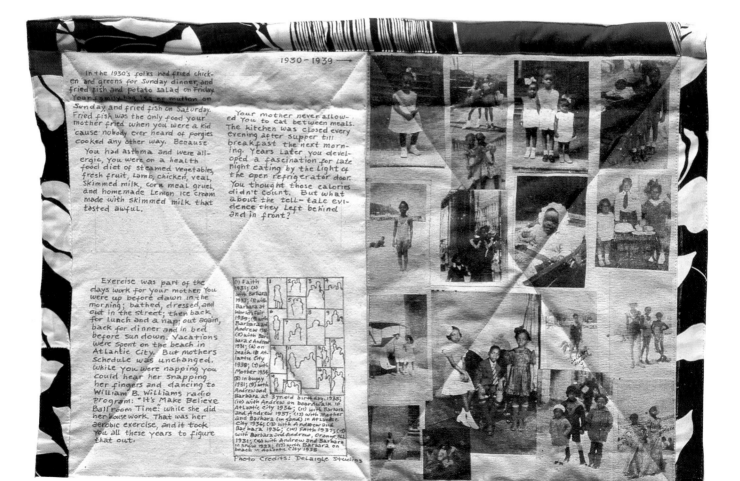

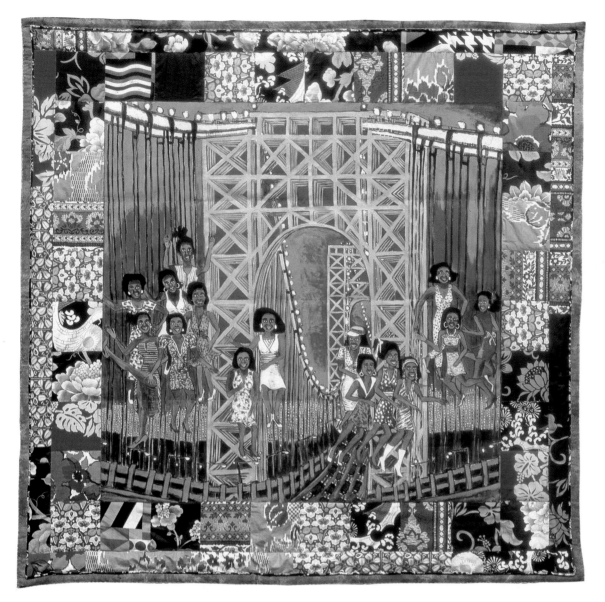

*Dancing on the George Washington Bridge* has a similar message — that of being free and able to reach your highest goals. This story quilt is one in a series of five, which Ringgold designed to show women claiming the bridges of New York and San Francisco. Recalling her childhood fascination with the George Washington Bridge, she considered it to be a "magnificent masculine structure." Onto her story quilt, she now would paint fifteen women flying, dancing, laughing, and singing above that bridge and the skyline. Their colorful patterned dresses unite the canvas with the patterned cloth border.

Faith Ringgold. **Dancing on the George Washington Bridge.** *The Woman on a Bridge Series. 1988. Acrylic on canvas; pieced fabric borders. 68 x 68 inches. Collection of Roy Eaton.*
Ringgold likes the way bridges are formed because they remind her of quilts floating in air. She sees their triangles as being little quilt patches of air separated by the girders.

25

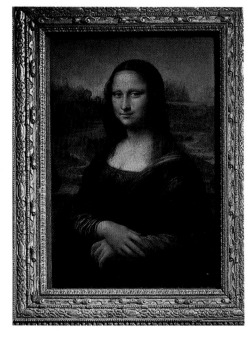

Leonardo da Vinci. **Mona Lisa.** *Paris, Louvre. SCALA/ ART RESOURCE, NEW YORK (K 80332).* Leonardo da Vinci was a well-known artist of the Renaissance period in Europe. He lived about five hundred years ago. His paintings are carefully preserved in museums such as the Louvre. The *Mona Lisa* is so popular that people stand in line to see it.

In 1991, Ringgold traveled to Paris to begin working on a series of story quilts called the French Collection. These twelve story quilts tell the adventures of an African-American woman named Willia Marie Simone, who was born in Faith's imagination. She does things Ringgold never did but would like to have done — such as study art for years by herself in Paris. Willia's story makes us aware of the struggle that all women artists have faced in the male-centered art world.

The story starts in 1920, when sixteen-year-old Willia leaves Harlem to become an artist in Paris. Willia's mother has a sister, Aunt Melissa, who wants Willia to develop her artistic talents. So she has suggested the trip and has given Willia five hundred dollars to help with expenses. Years later, Willia will send her two children to live with Aunt Melissa because Willia is determined to become a professional artist in Paris. She eventually becomes a world-famous painter and enjoys being among the inner circles of Parisian artists.

In *Dancing at the Louvre*, Willia helps her friend Marcia take her three daughters to visit the Louvre, a historic museum in Paris. The children dance in front of the familiar painting the *Mona Lisa*, by Leonardo da Vinci.

By posing the children as dancers beneath the *Mona Lisa*, Ringgold revealed her feelings about European art. Traditionally African-Americans and women were not included among the inner circles of European artists. So Ringgold depicted the figures in this piece observing European art with interest but also with lightheartedness. Even Ringgold's *Mona Lisa*, with her half-smile, seems to be amused at the romping and dancing below. She appears to understand Ringgold's intent for these viewers to

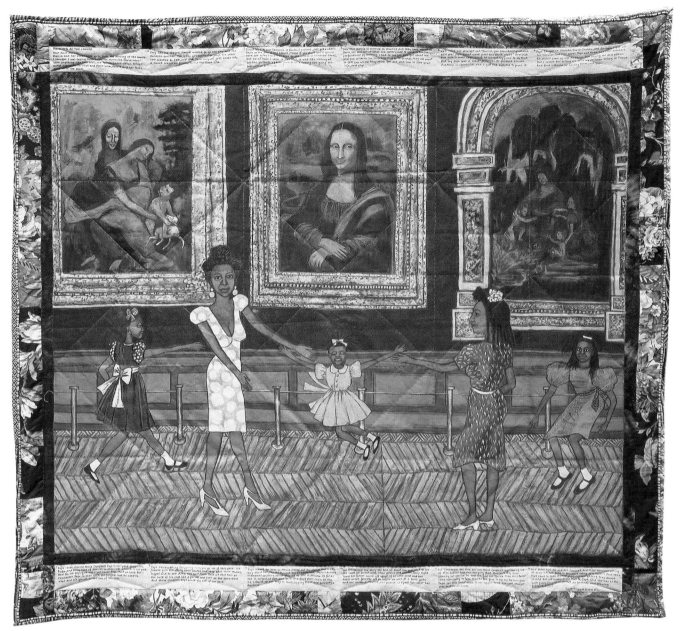

appreciate European art, as long as they do not take it too seriously.

As models for this story quilt, Ringgold used photographs of her own family. Marcia and her children look like Ringgold's daughter Barbara and her children, Baby Faith, Teddy, and Martha. Willia Marie resembles Ringgold's mother as a young woman. In fact, Willia's personality was inspired by Ringgold's memories of Willi. Willia Marie's story is written across the top and bottom of the quilt. A patterned border frames the brightly painted canvas.

Faith Ringgold. **Dancing at the Louvre.** *The French Collection Part I. 1991. Acrylic on canvas; pieced fabric borders. 73½ x 80½ inches.* Ringgold used artistic freedom to reproduce the paintings that hang in the Louvre. She purposely altered the colors and frames — even the sizes of the reproductions. For example, in real life, the *Mona Lisa* is smaller than it appears on the story quilt. Perhaps Ringgold enlarged the piece because of its importance in the story.

27

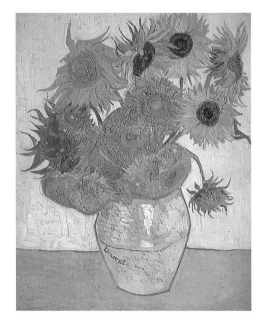

Vincent van Gogh.
**Sunflowers.** *1888. Munich,*
*Neue Pinakothek. SCALA/ART*
*RESOURCE, NEW YORK.*
Dutch painter Vincent van
Gogh (1853–1890) never
knew that his artwork would
someday become famous.
Today his paintings are popu-
lar throughout the world.

Another quilt in the French Collection tells the story of Willia at a meeting of an imaginary group called the National Sunflower Quilters Society of America. African-American women who changed history work on a quilt of sunflowers. Standing in the sunflower field is Dutch artist Vincent van Gogh, who painted many still life images of sunflowers during his lifetime.

When the sun goes down, the women finish piecing their quilt. The story reads that van Gogh "just settled inside himself, and took on the look of the sunflowers in the field as if he were one of them." In this way, Ringgold contrasts the way that some men traditionally have created art — alone with their paints — with the method of the women quilters, who work as a team.

**Diagram of #4 The**
**Sunflowers Quilting Bee at**
**Arles.** *Reprinted by permission*
*of Melissa McGrath.*

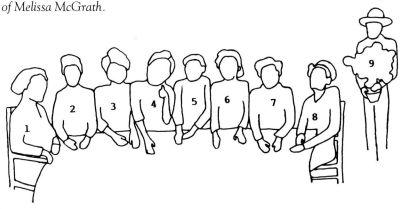

1. Madame Walker, business-
   woman
2. Sojourner Truth, social
   reformer
3. Ida Wells, journalist
4. Fannie Lou Hamer, civil
   rights activist
5. Harriet Tubman, abolitionist
6. Rosa Parks, civil rights
   activist

7. Mary McLeod Bethune,
   educator
8. Ella Baker, civil rights
   activist
9. Vincent van Gogh

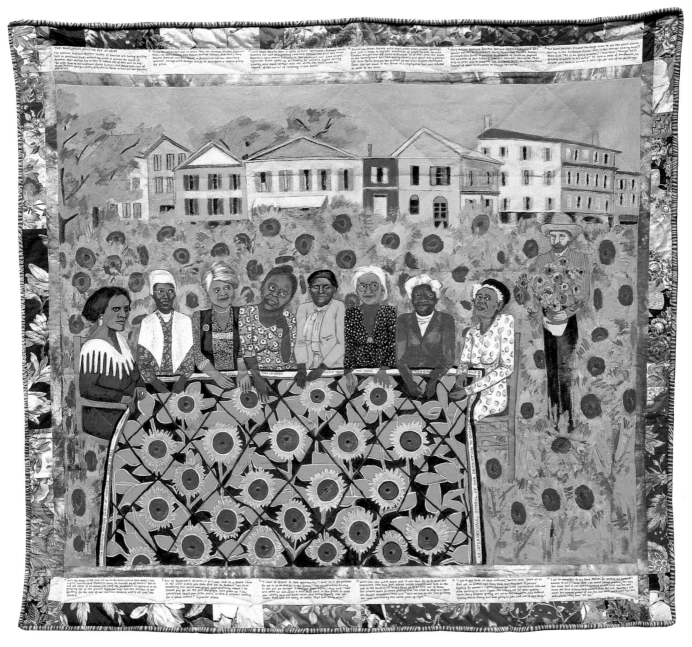

Faith Ringgold. **#4 The Sunflowers Quilting Bee at Arles.** *The French Collection Part I. 1991. Acrylic on canvas; pieced fabric. 74 x 80 inches. Private collection.*

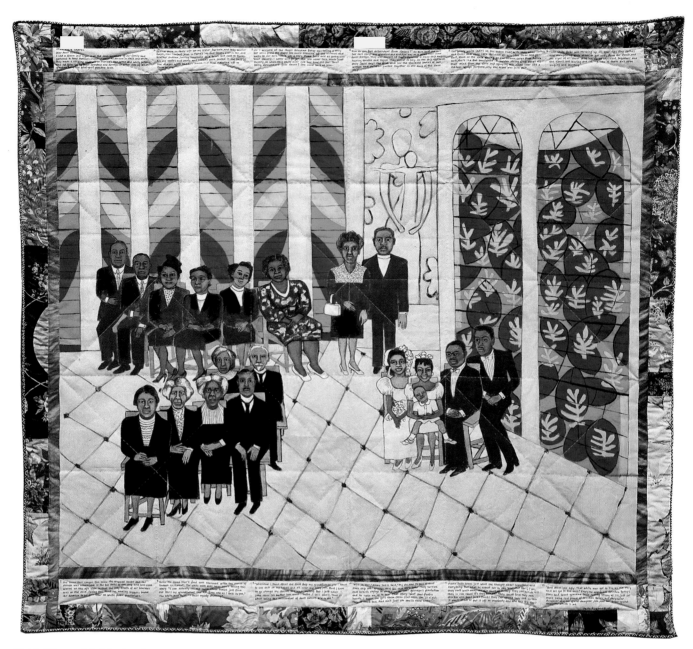

Faith Ringgold. **Matisse's Chapel.** *The French Collection, Part I. 1991. Acrylic on canvas; pieced fabric borders. 74 x 79½ inches.*

The bright colors, flat shapes, exciting patterns, and simple lines of Matisse's chapel are present in Ringgold's story quilt. Again, she used artistic freedom to reproduce the art of a European male artist. It is interesting to note that Ringgold painted Ralph, the brother she never knew, on Willi's lap.

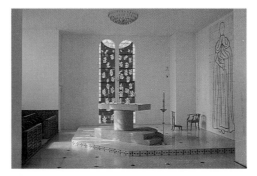

**The Chapel of Vence.**
*Photograph by Hélène Adant.*
From his wheelchair, Matisse used his scissors as he would have used a chisel, carving with color the large paper shapes as designs for stained glass windows of the chapel.

As Ringgold traveled in France to gather ideas for the French Collection, she visited a chapel designed by Henri Matisse, a well-known French artist. *Matisse's Chapel* became a story quilt based on an imaginary gathering of Faith's own relatives in the chapel. In the story quilt, they are known, of course, as Willia Marie's family.

At the time that Ringgold painted *Matisse's Chapel*, everyone in the image had died. From photographs and memories, she re-created their likenesses. Their talk is of slavery. Their hearts are bitter. But their pride is still alive.

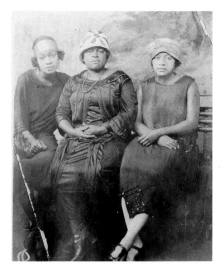

Faith Ringgold's mother, Willi Posey, with her sisters, Bessie and Edith. *c. 1920s.*

**Diagram of Matisse's Chapel.**
*Reprinted by permission of Melissa McGrath.*

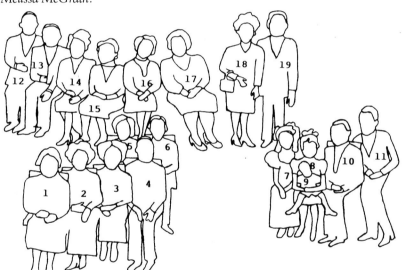

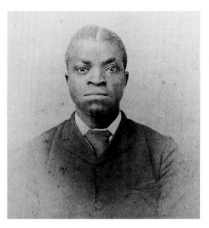

Faith Ringgold's grandfather Professor Bunyon Posey. *c. 1880s.*

1. Ida Posey, grandmother
2. Susie Shannon, great-great-grandmother
3. Betsy Bingham, great-grandmother
4. Professor Bunyon Posey, grandfather
5. Aunt Janie, grandaunt
6. Uncle Peter, granduncle
7. Barbara Knight, sister
8. Willi Posey (Jones), mother
9. Ralph, brother who died as a baby
10. Andrew Louis Jones, Sr., father
11. Andrew Louis Jones, Jr., brother
12. Uncle Hilliard
13. Uncle Cardoza
14. Aunt Edith
15. Aunt Bessie
16. Mildred, cousin
17. Ida Mae, cousin
18. Baby Doll Hurd, grandmother
19. Rev. Jones, grandfather

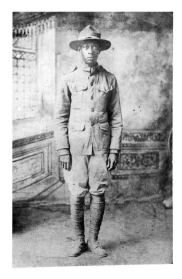

Faith Ringgold's Uncle Cardoza Posey in his World War I uniform. *1919.*

**Faith Ringgold and Baby Faith.** *1989. Photograph © Lucille Tortora.* Ringgold has received six honorary doctorates from several colleges and universities. Other awards include a Caldecott Honor for her children's book *Tar Beach*, the Solomon R. Guggenheim Award, the Coretta Scott King Award for Illustration, and the Arts Award for Painting and Sculpture from the National Endowment for the Arts. Her name was on a *New York Times* list of Ten Major Women Artists, and her artwork is published in books for both children and adults. In this portrait, she embraces her granddaughter Baby Faith.

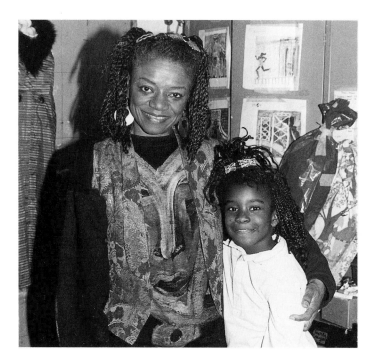

The French Collection became the last of Ringgold's quilts with a story written on the fabric. Just as Ringgold had hoped, publishers asked her to write and illustrate her stories as children's books. Her artwork can be found in the permanent collections of many museums throughout the world. Many private collectors, including Oprah Winfrey and Bill Cosby, own her work.

Today Ringgold divides her year between teaching as a full professor and doing her art. Until recently, she had a studio in the garment district of Manhattan, where Willi Posey first taught her to sew. Reminiscing, Ringgold says, "The neighborhood has a lot of memories for me because I used to go down there, and she'd take me into factories to buy fabric by the bolt. She would get a kick out of the fact that my studio was down there for a while."

Now Ringgold enjoys a new studio and home in Englewood, New Jersey, which is across the George Washington Bridge from Harlem. Reflecting upon a time long ago when she was even too young to sew with a machine, she says with a smile, "I still love that bridge."